Epic Dragon Age Adult Coloring Book

By Randy Norman

Copyright © 2017 Randy Norman

All rights reserved.

ISBN: 10: 1544787960
ISBN- 13: 978-1544787961

How would you like to be able to print off copies of your favorite coloring books?

How about having access to over a 1000's coloring books for the price of one coloring book every month.

Coupon Code to Join for only $1.00 for the first month when you sign up for the mailing list.

TRYTODAY

www.digitalcoloringbooks.com

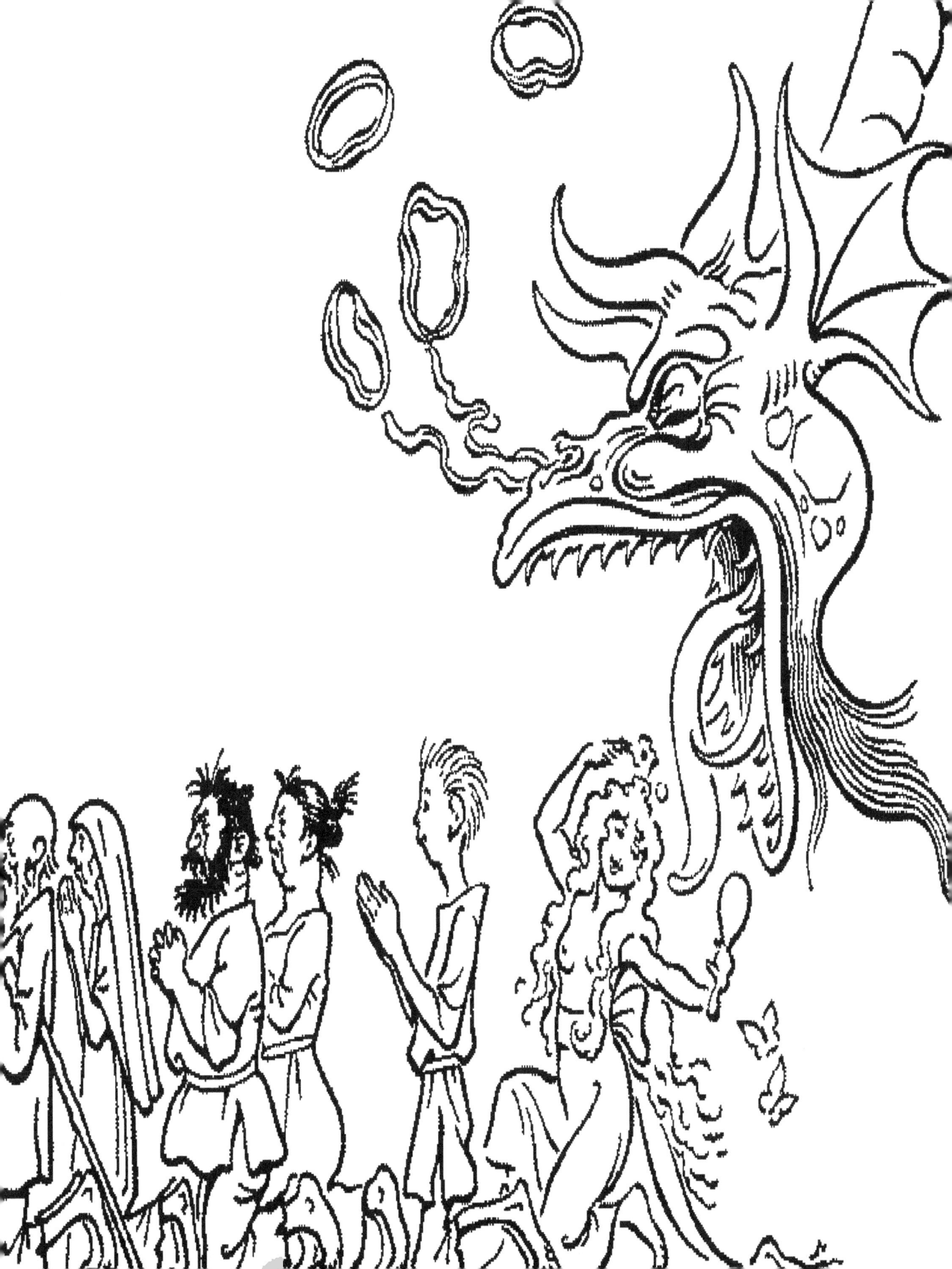

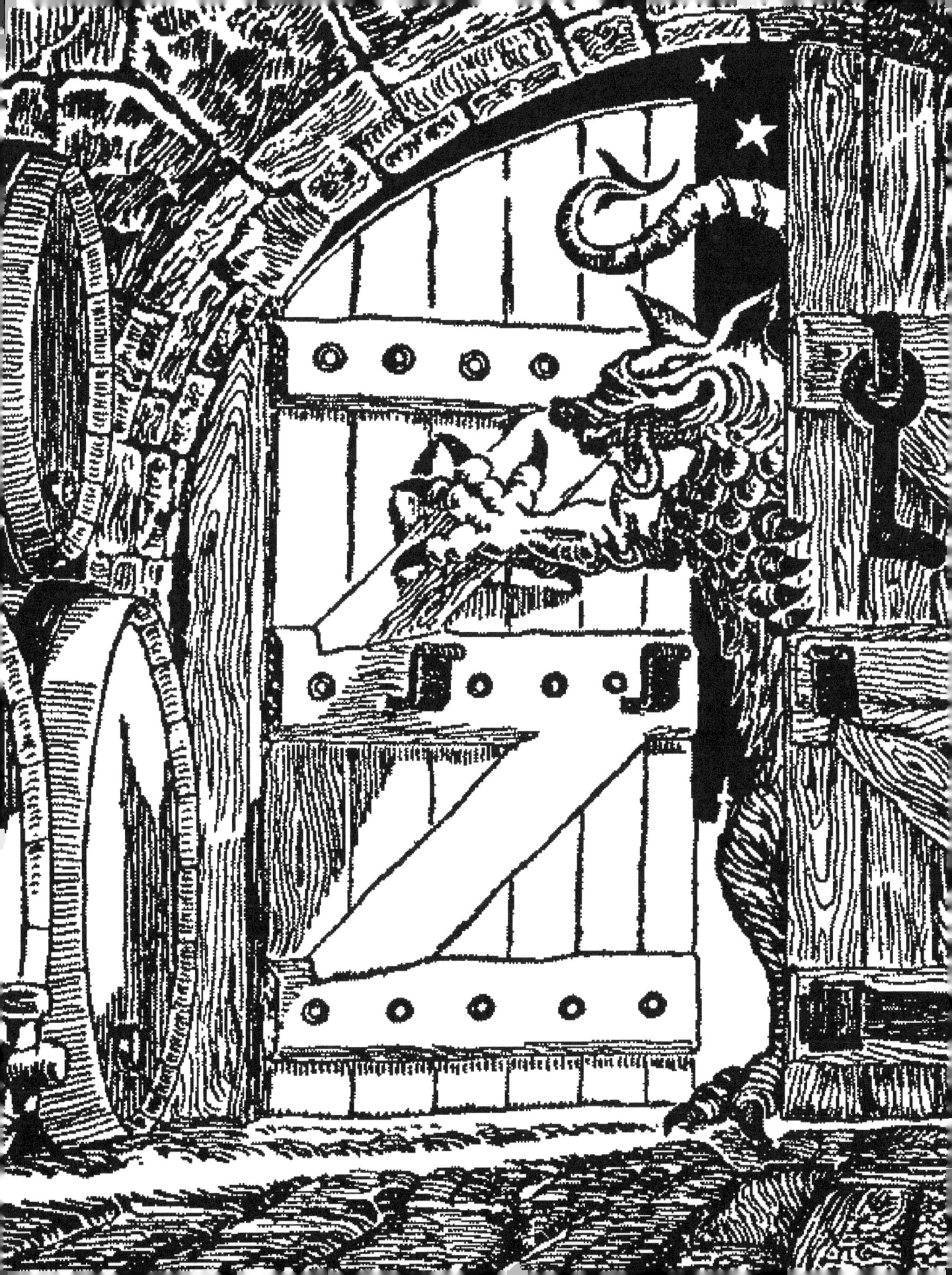

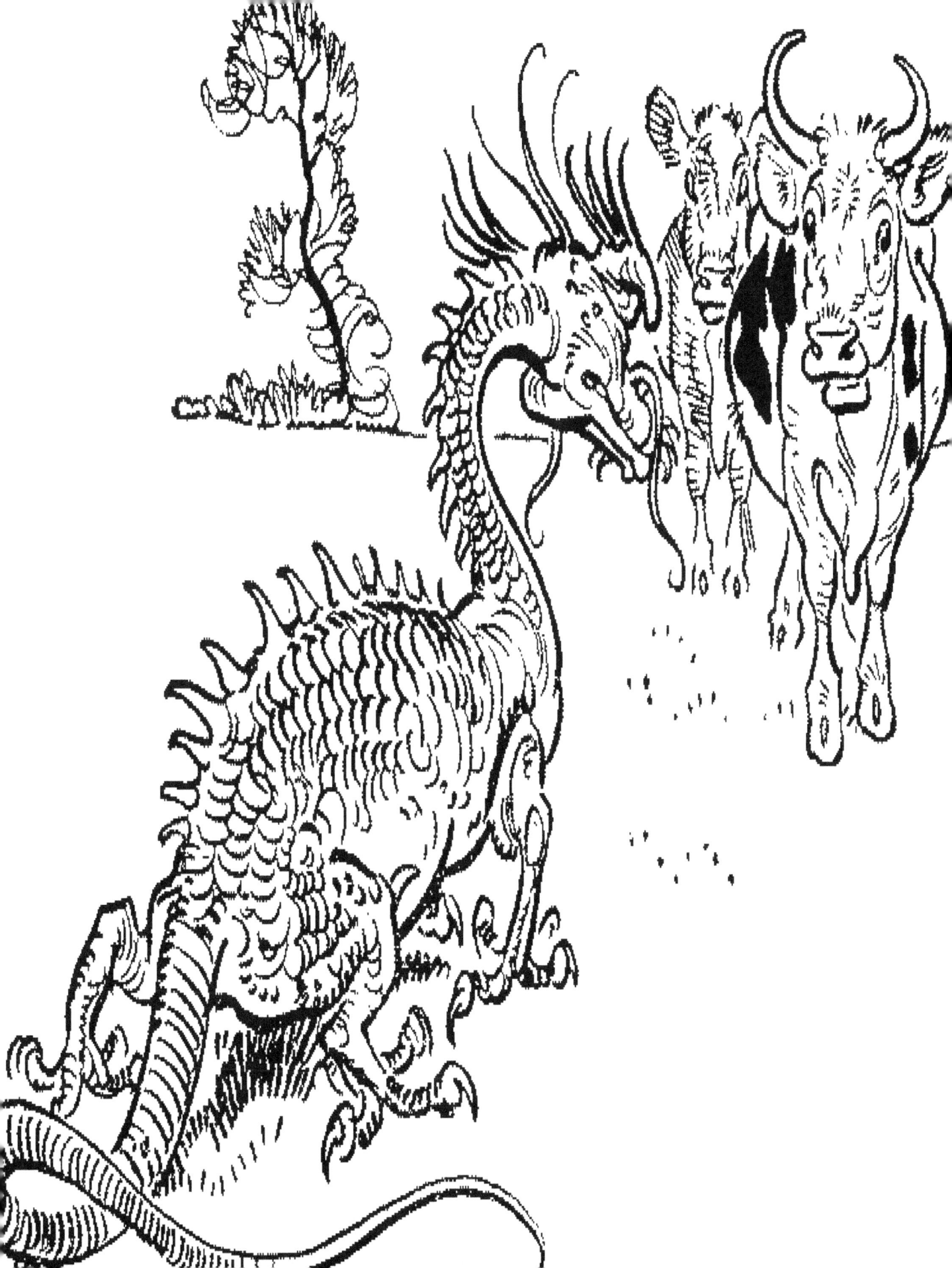

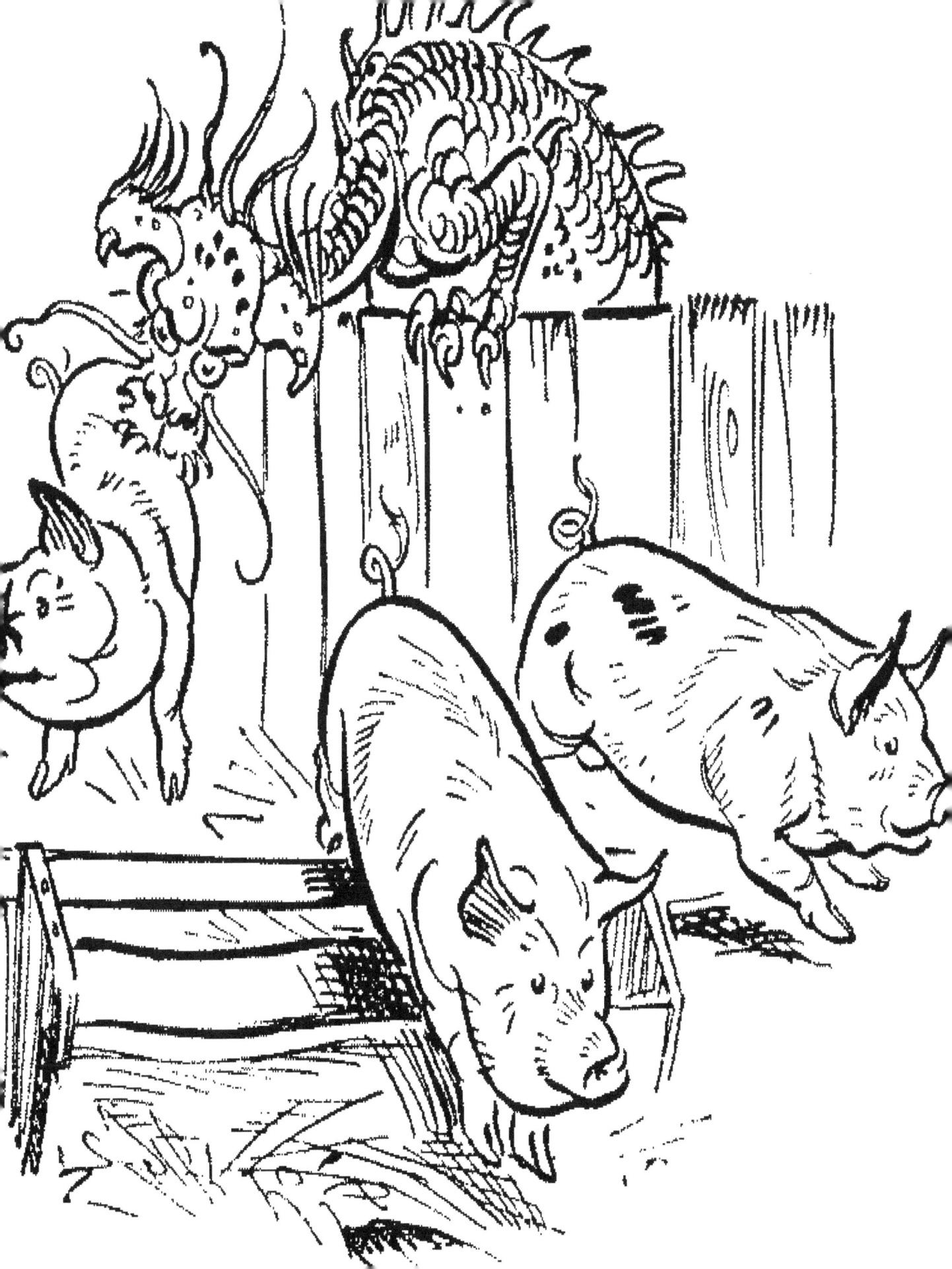

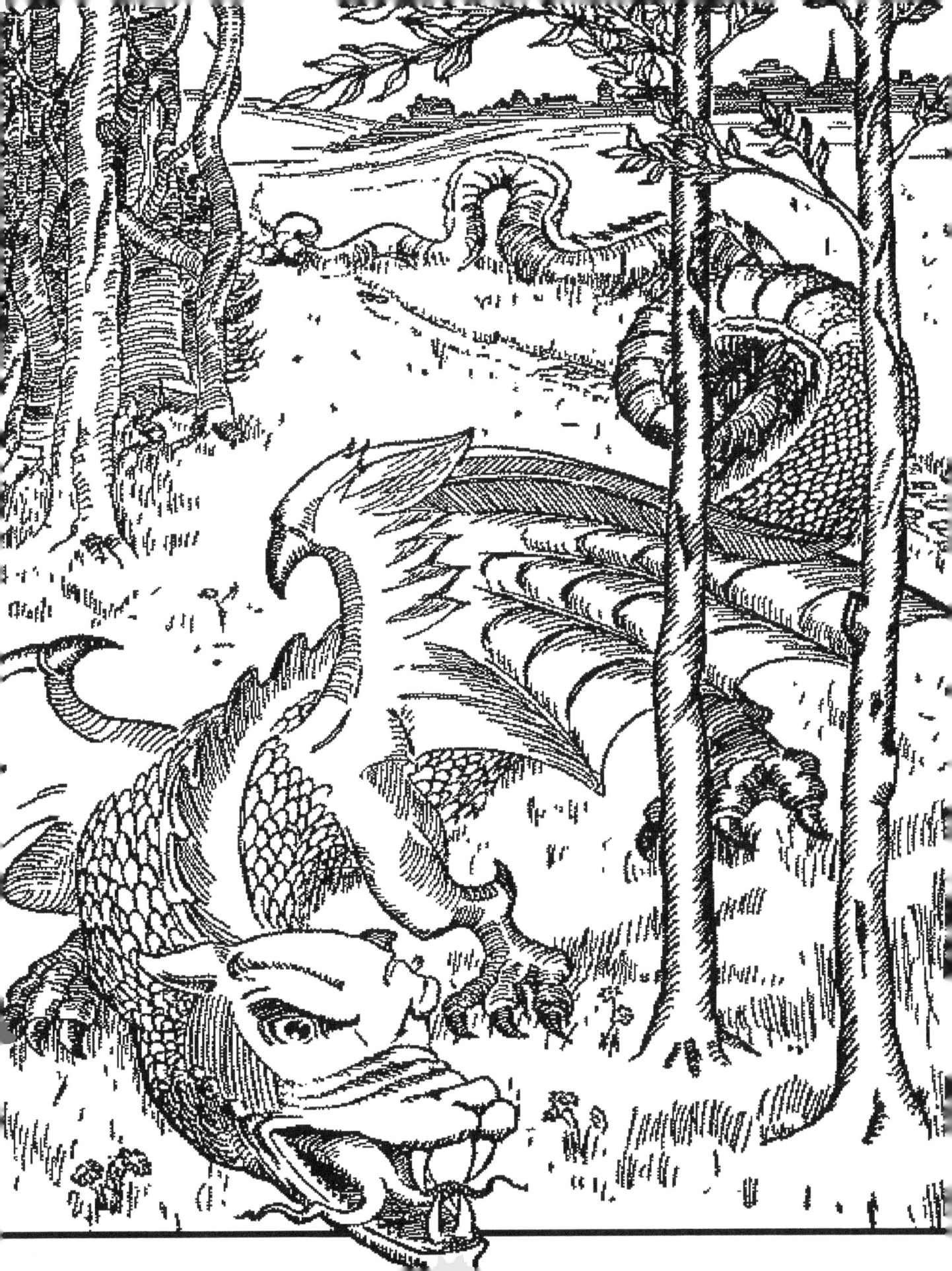

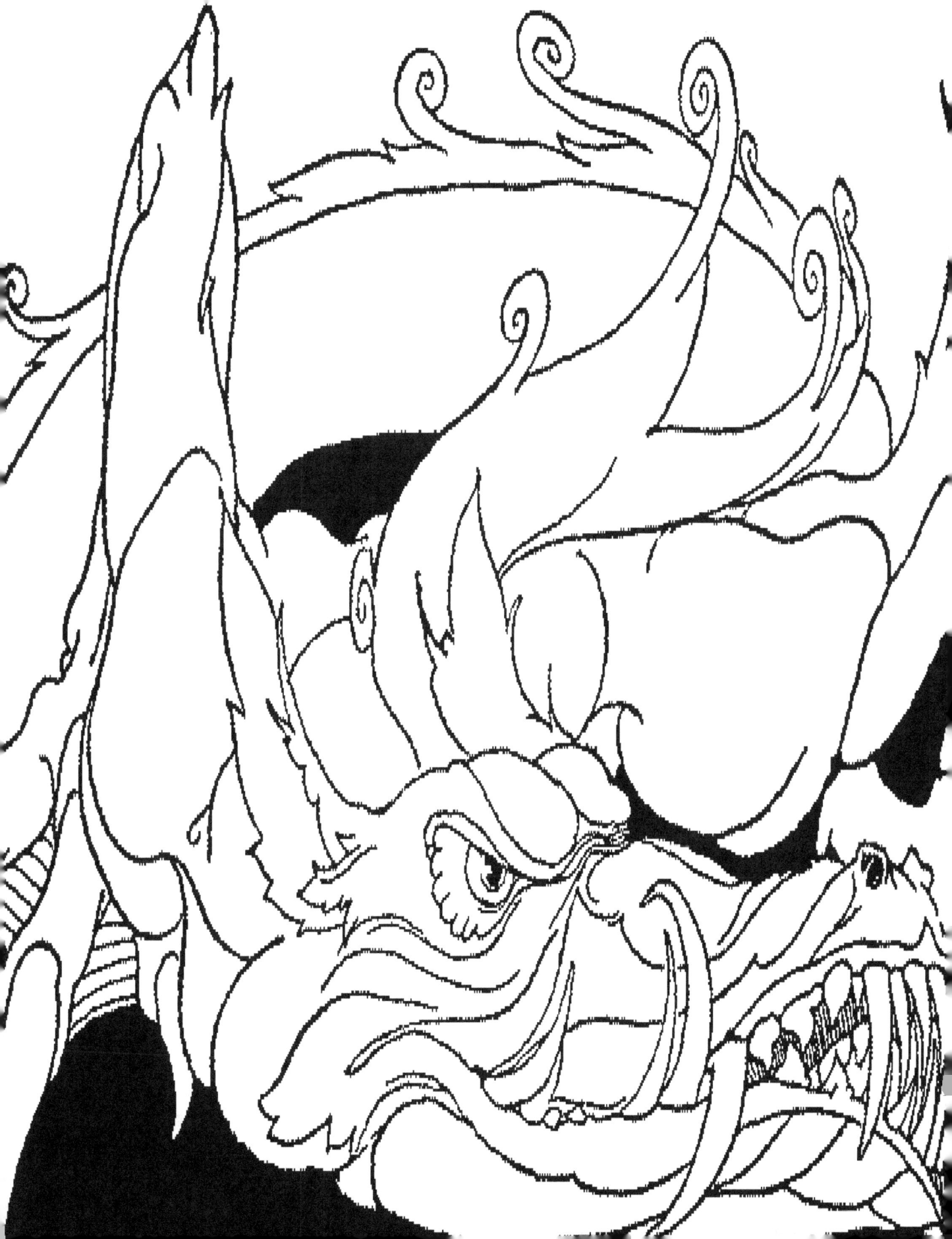

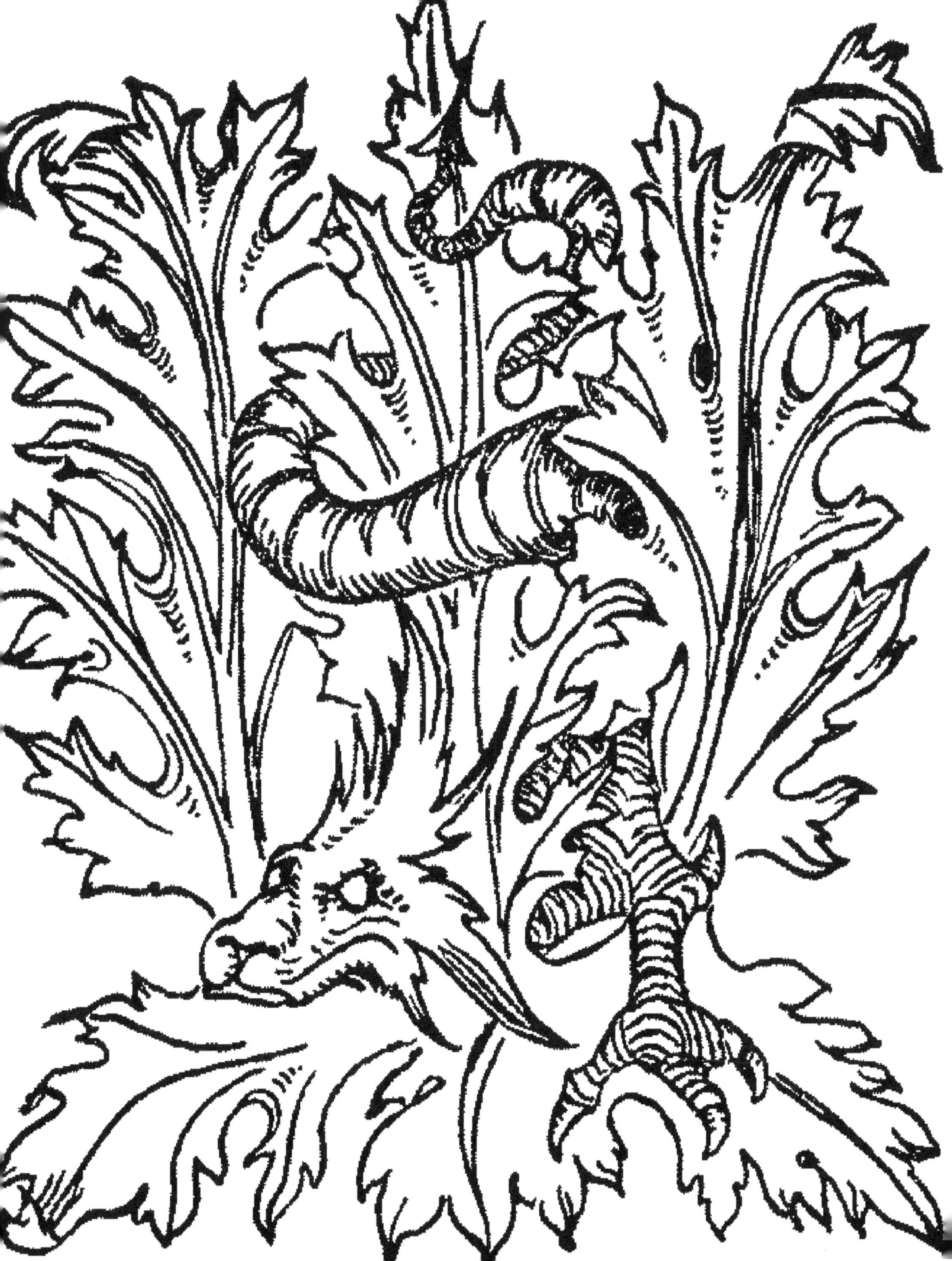

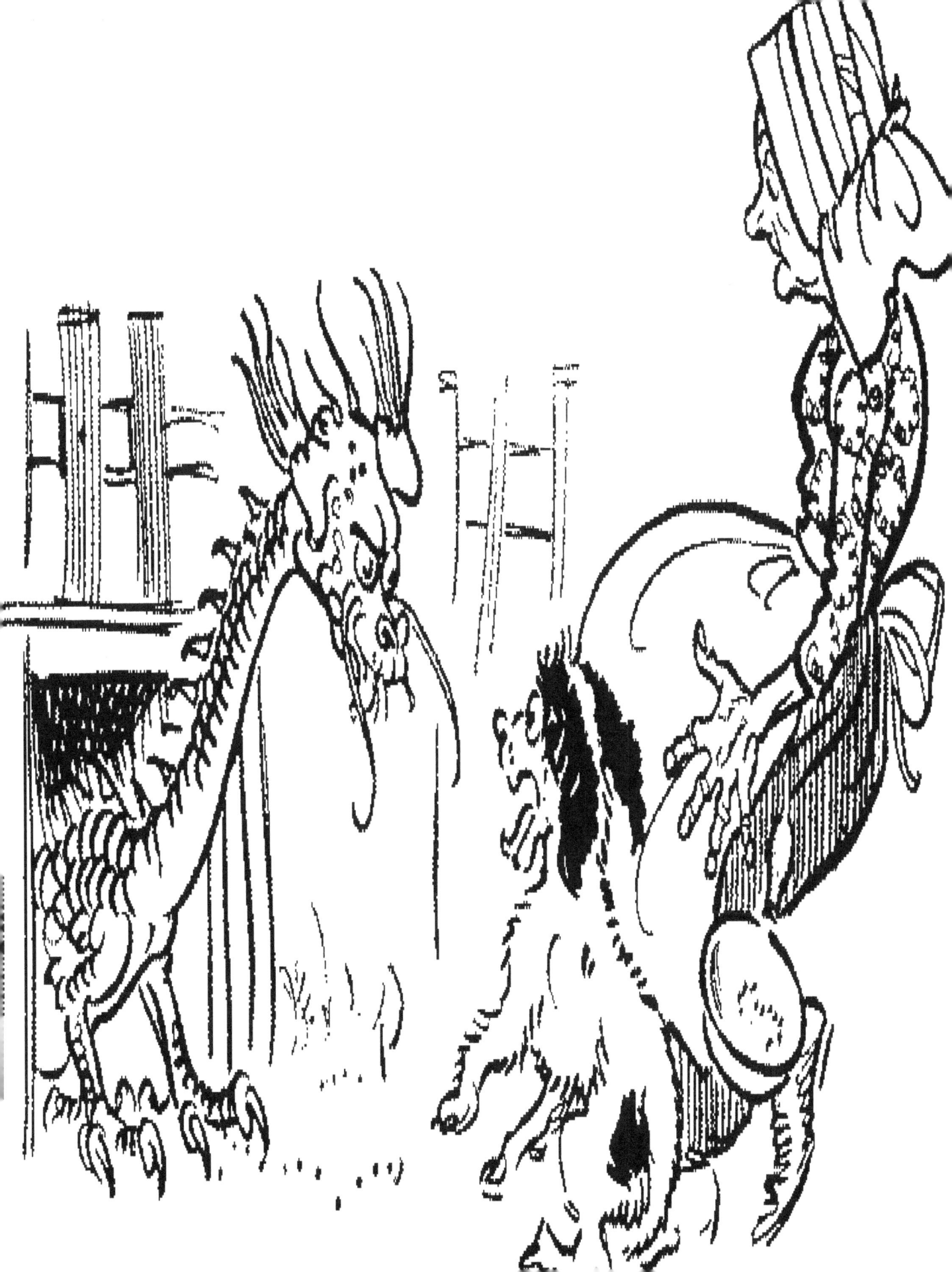

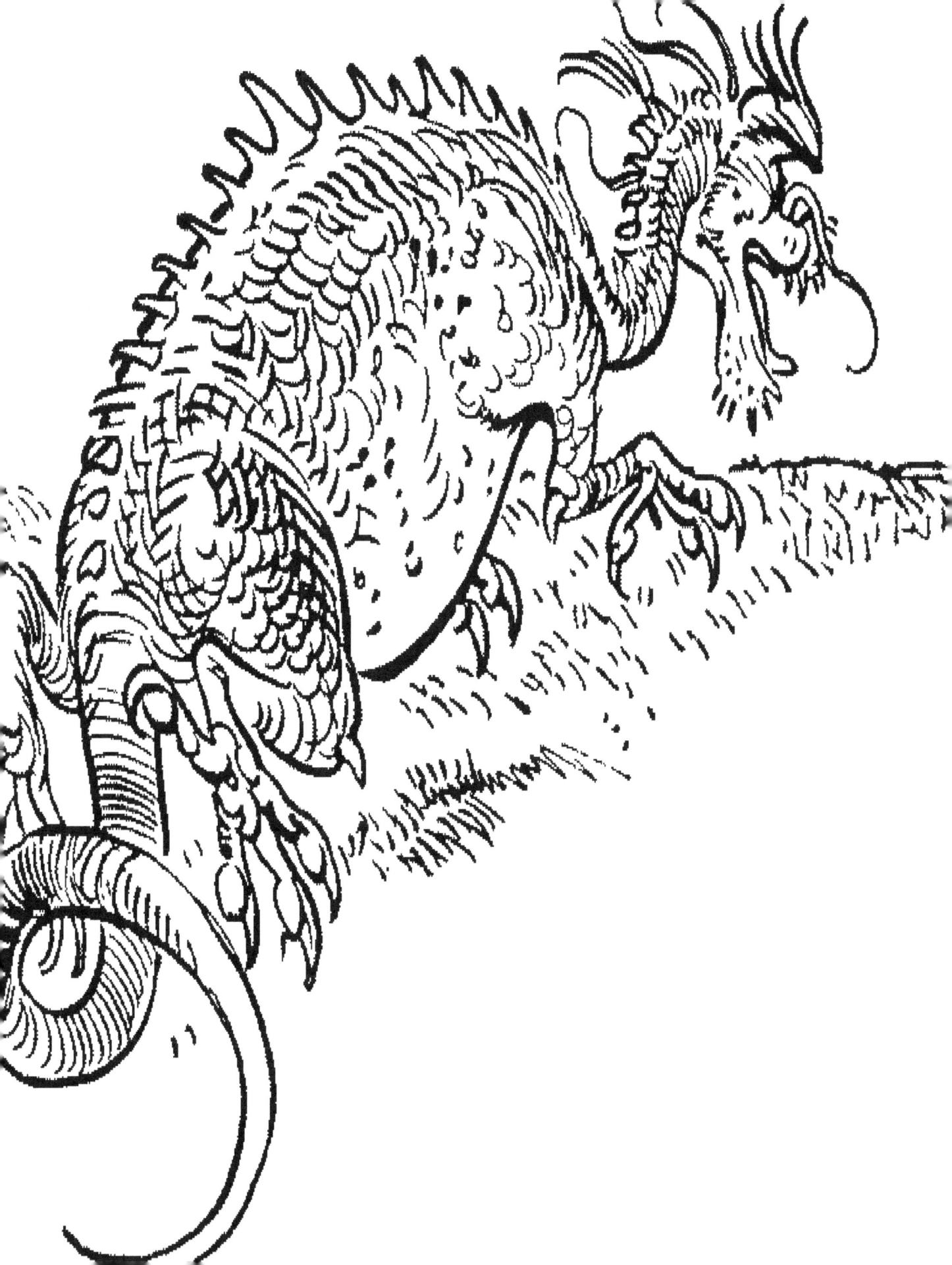

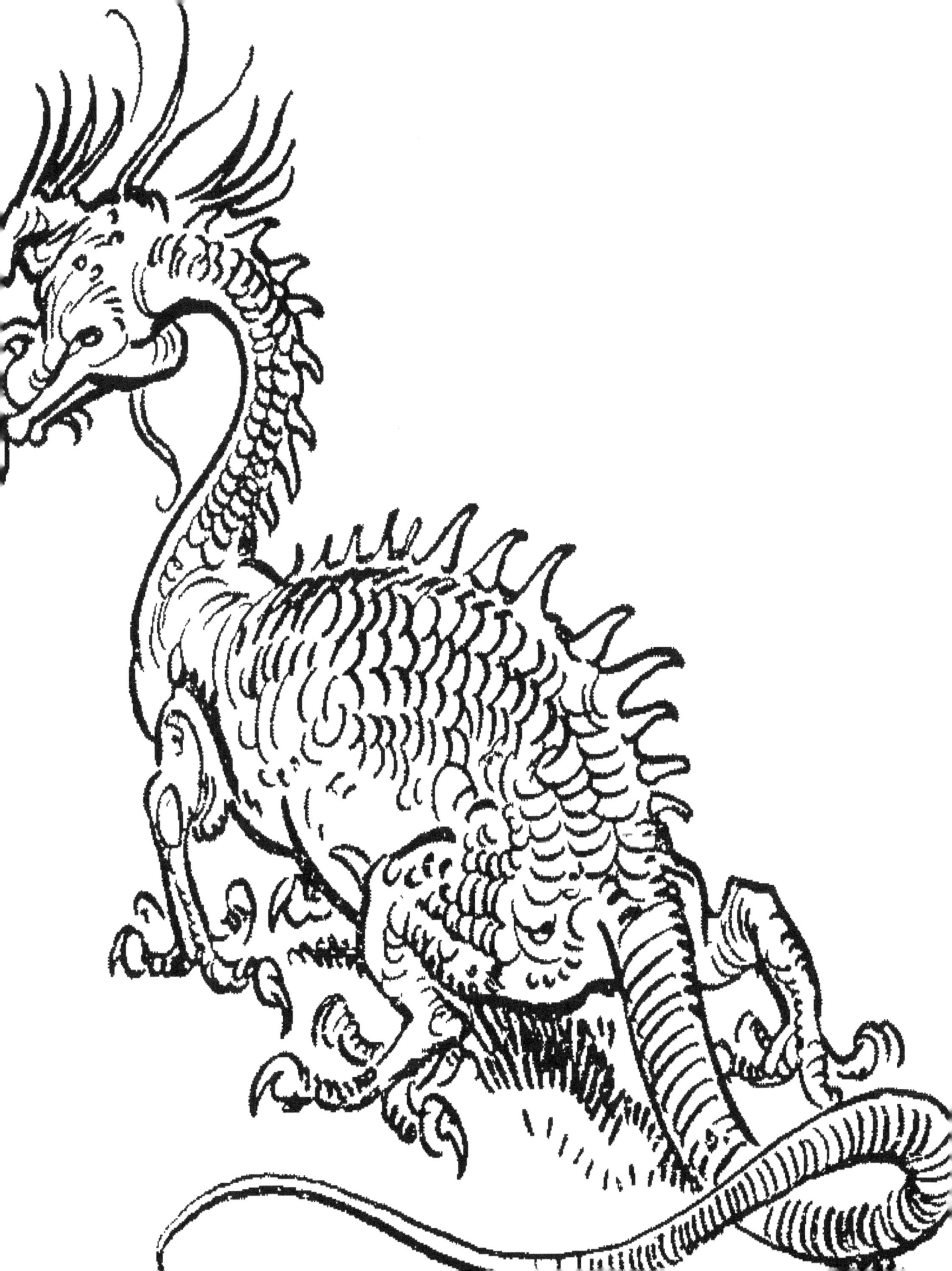

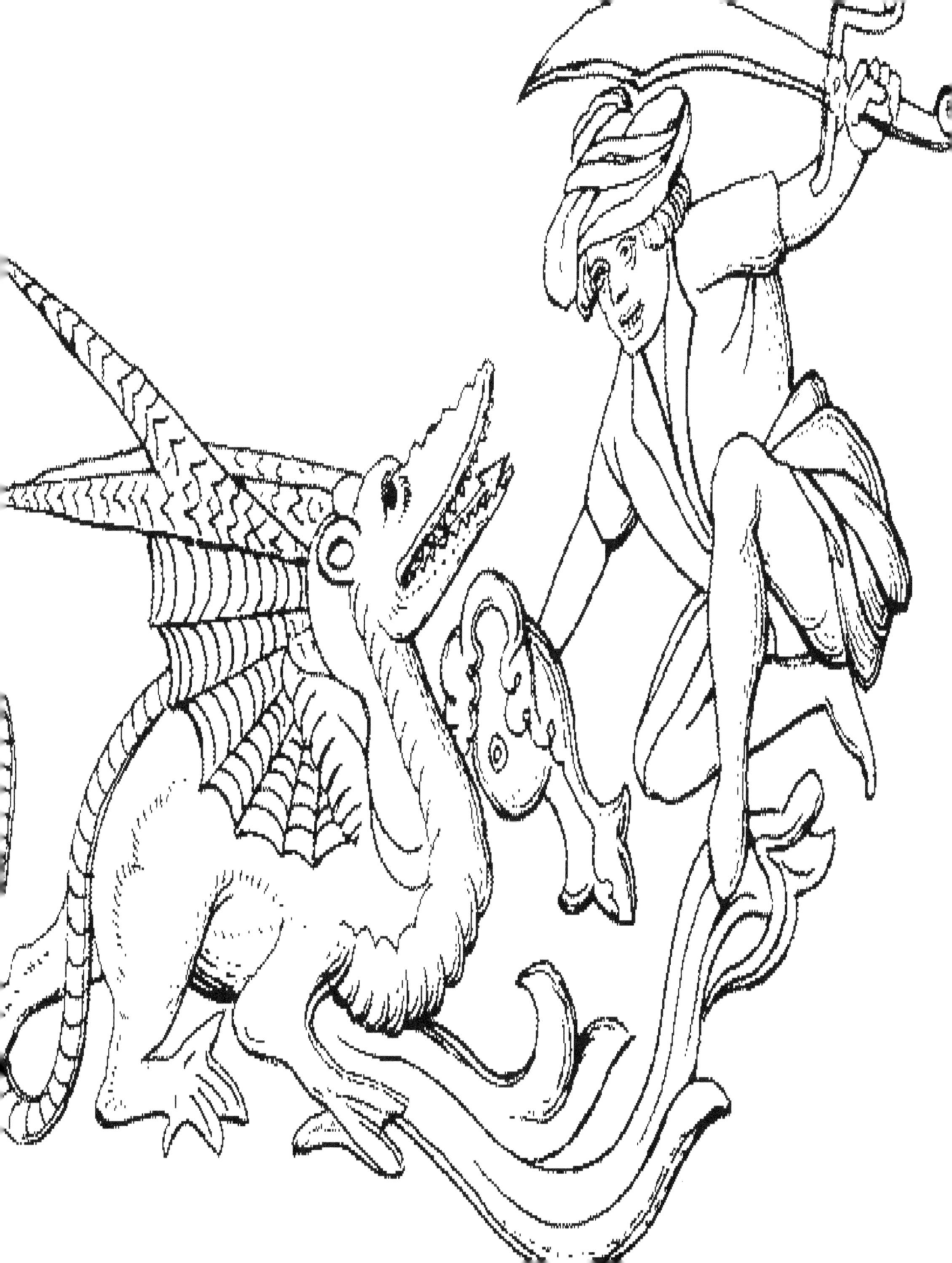

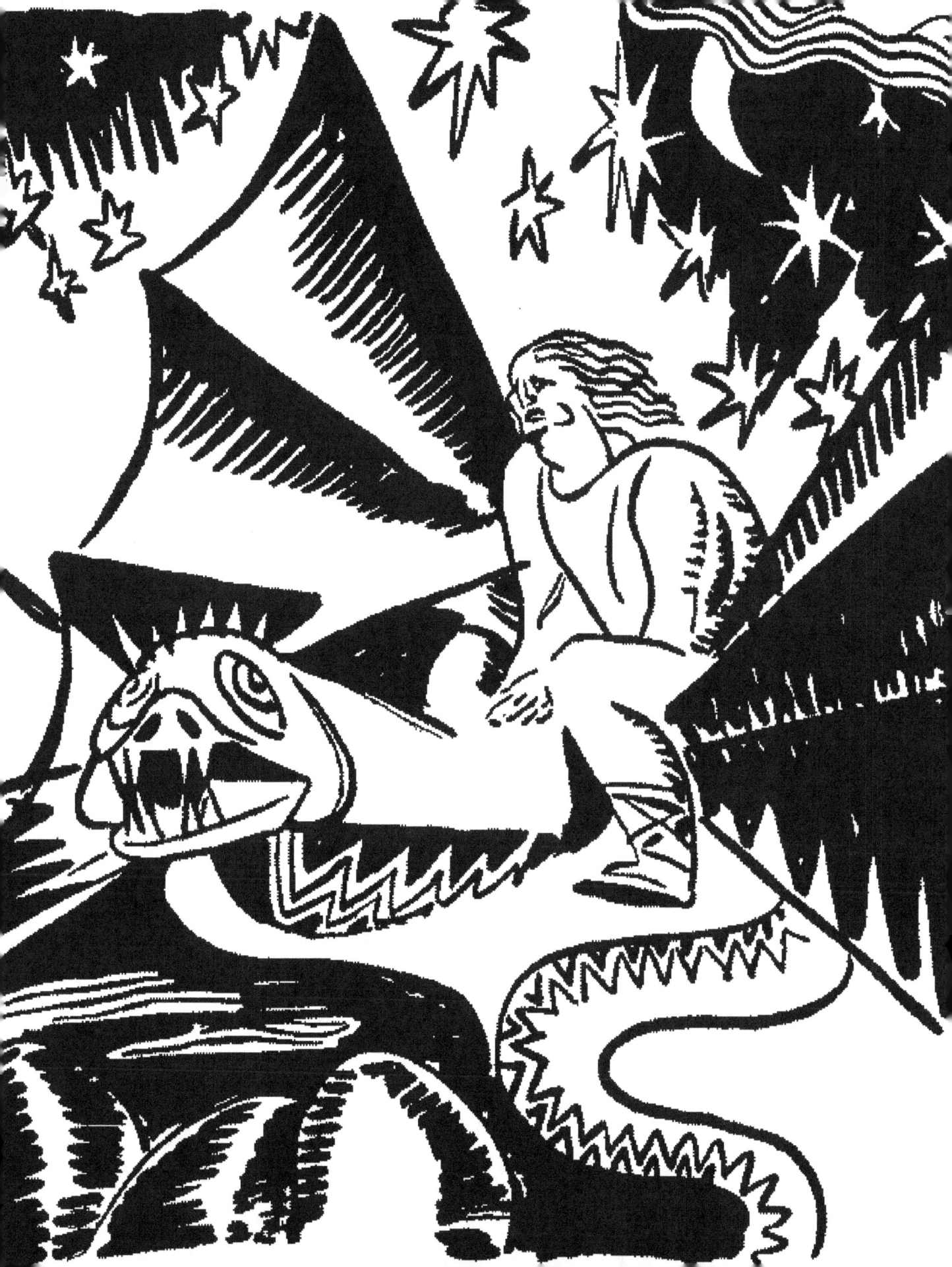

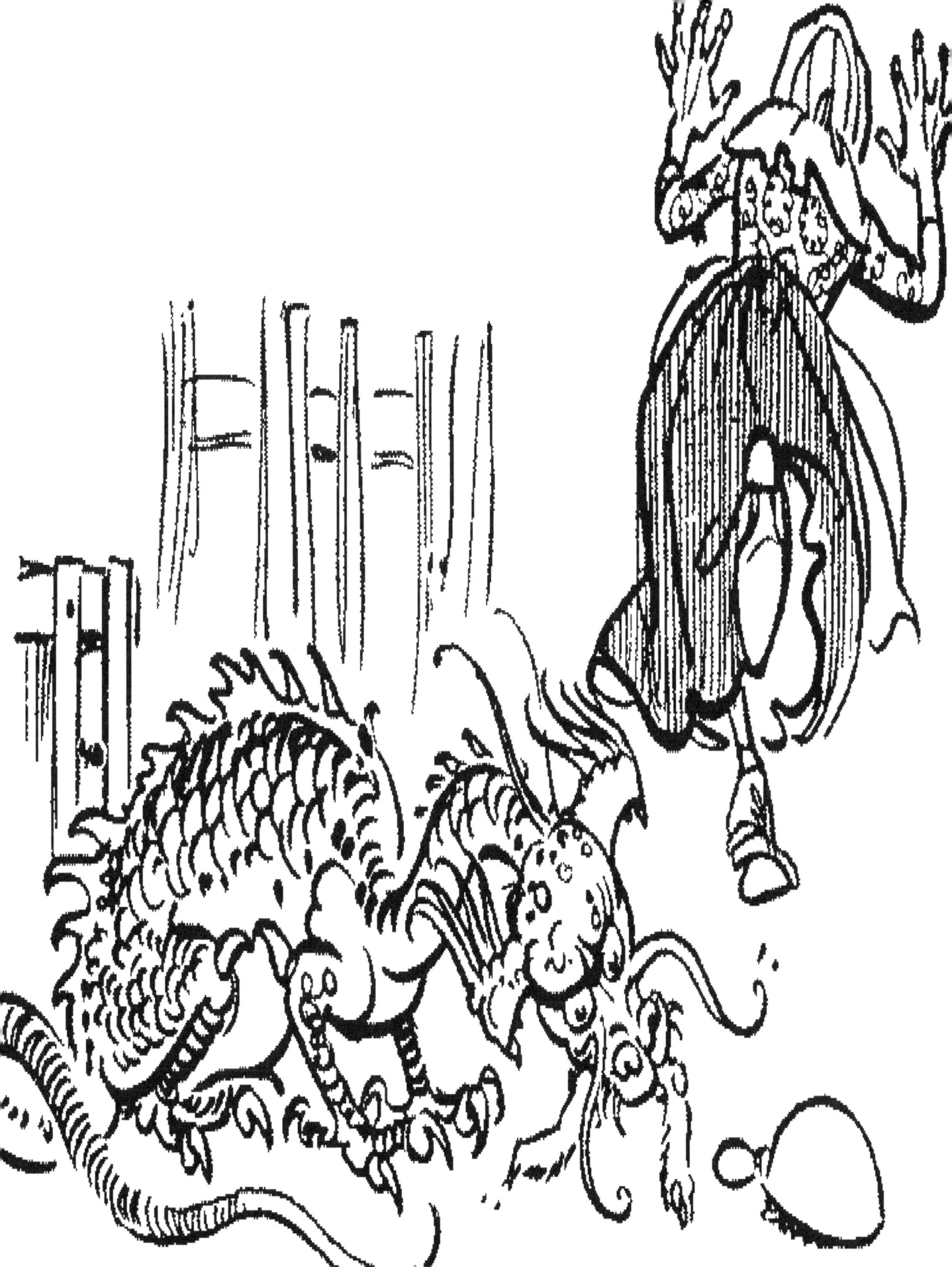

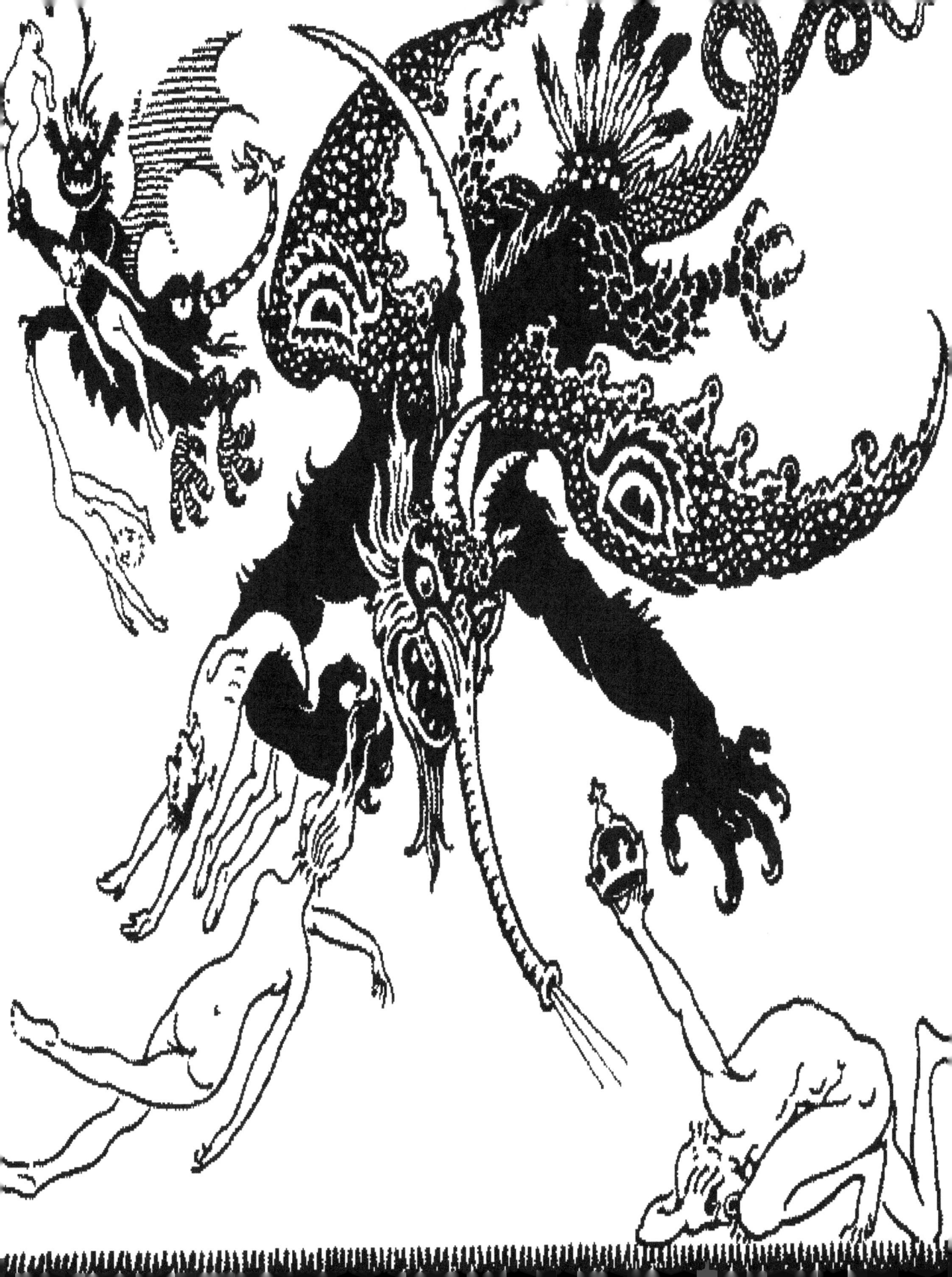

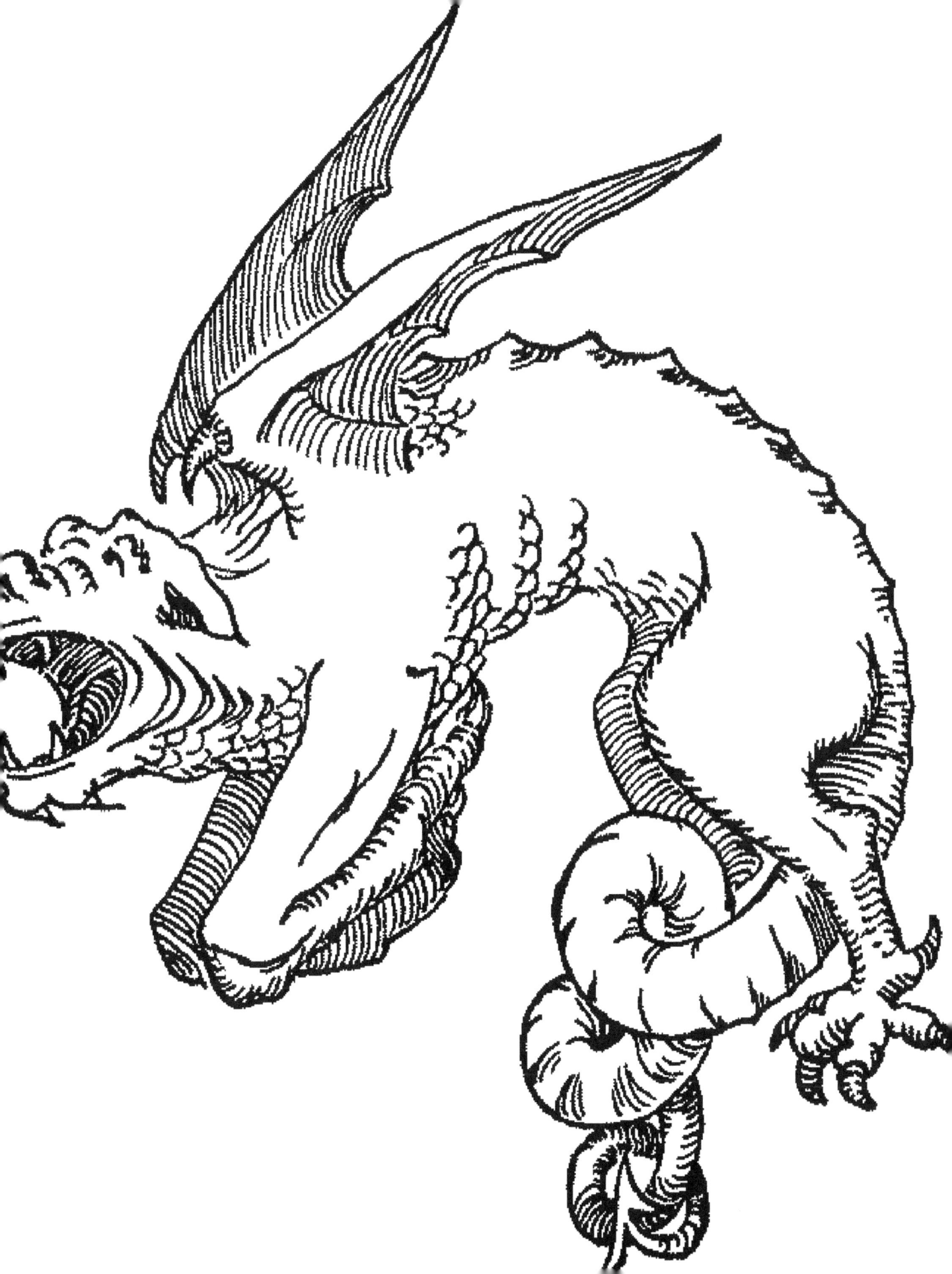

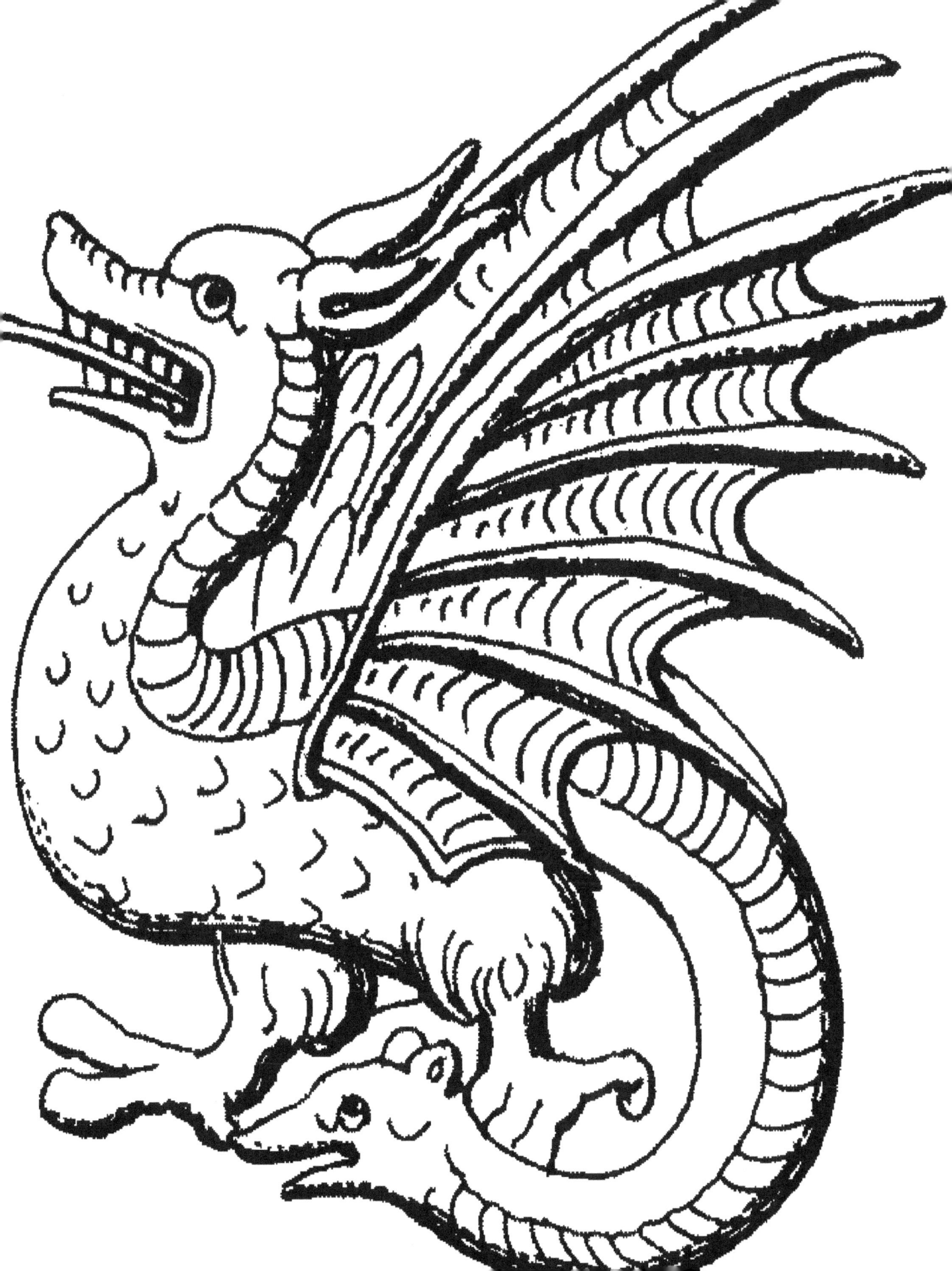

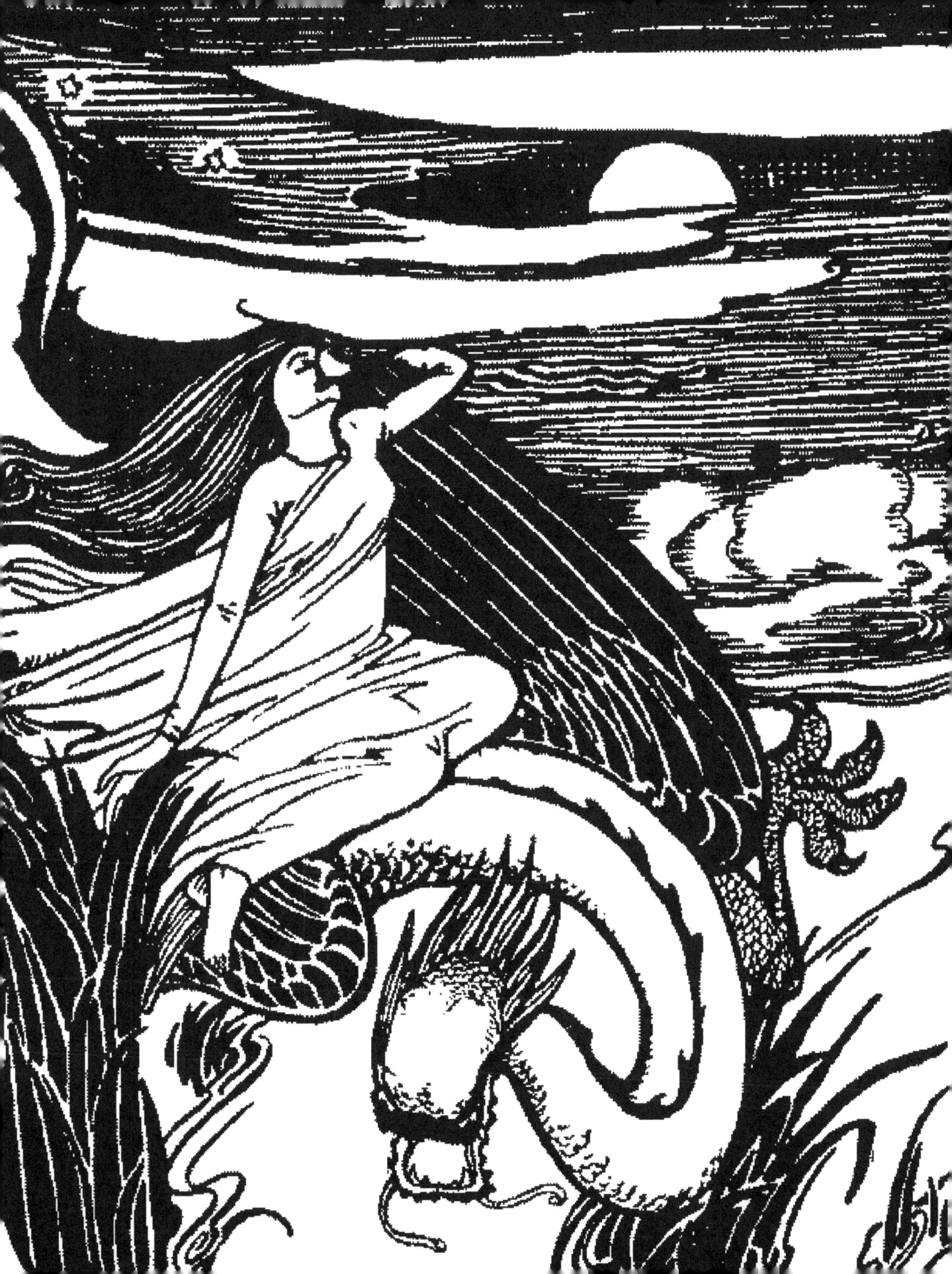

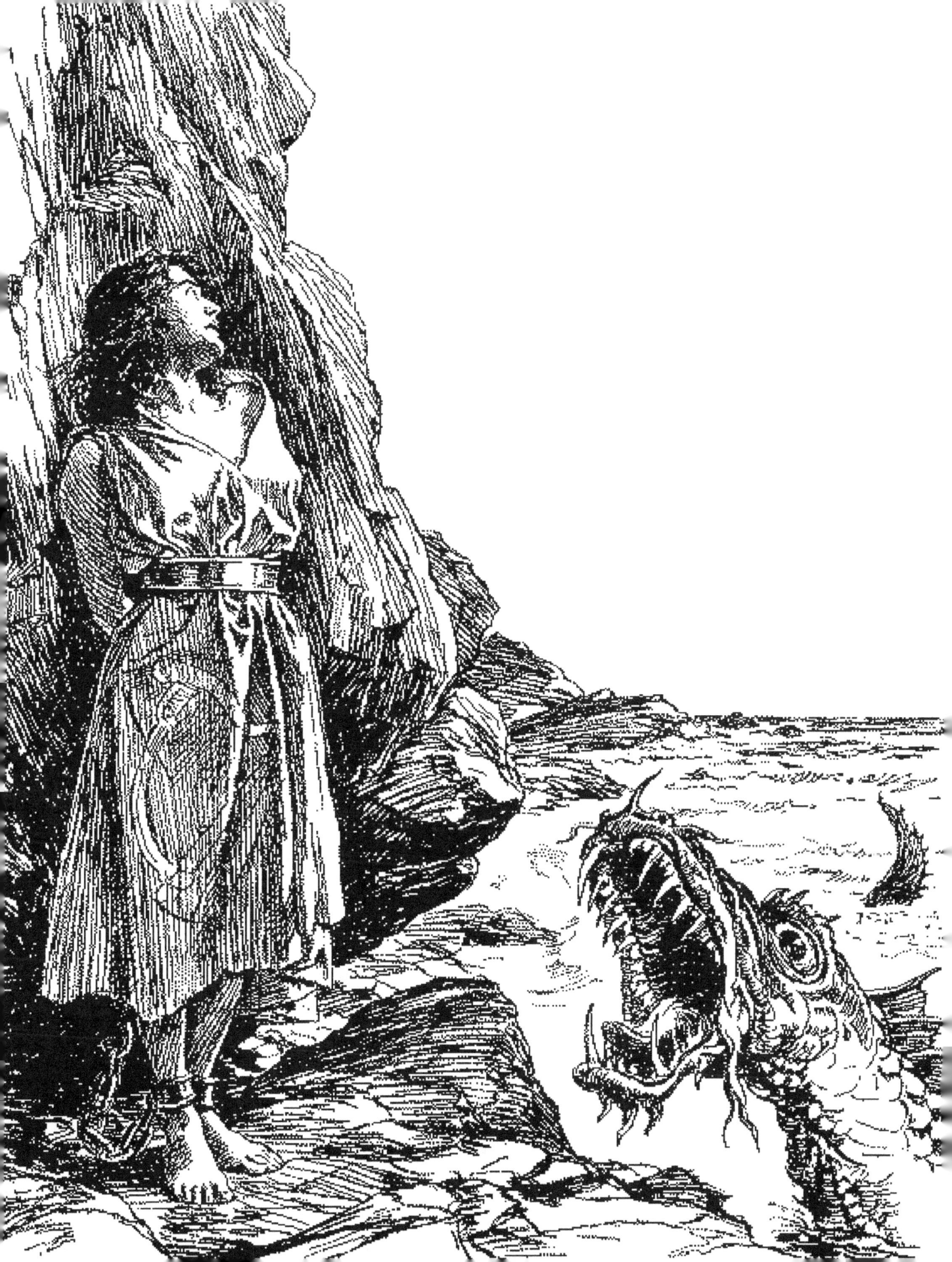

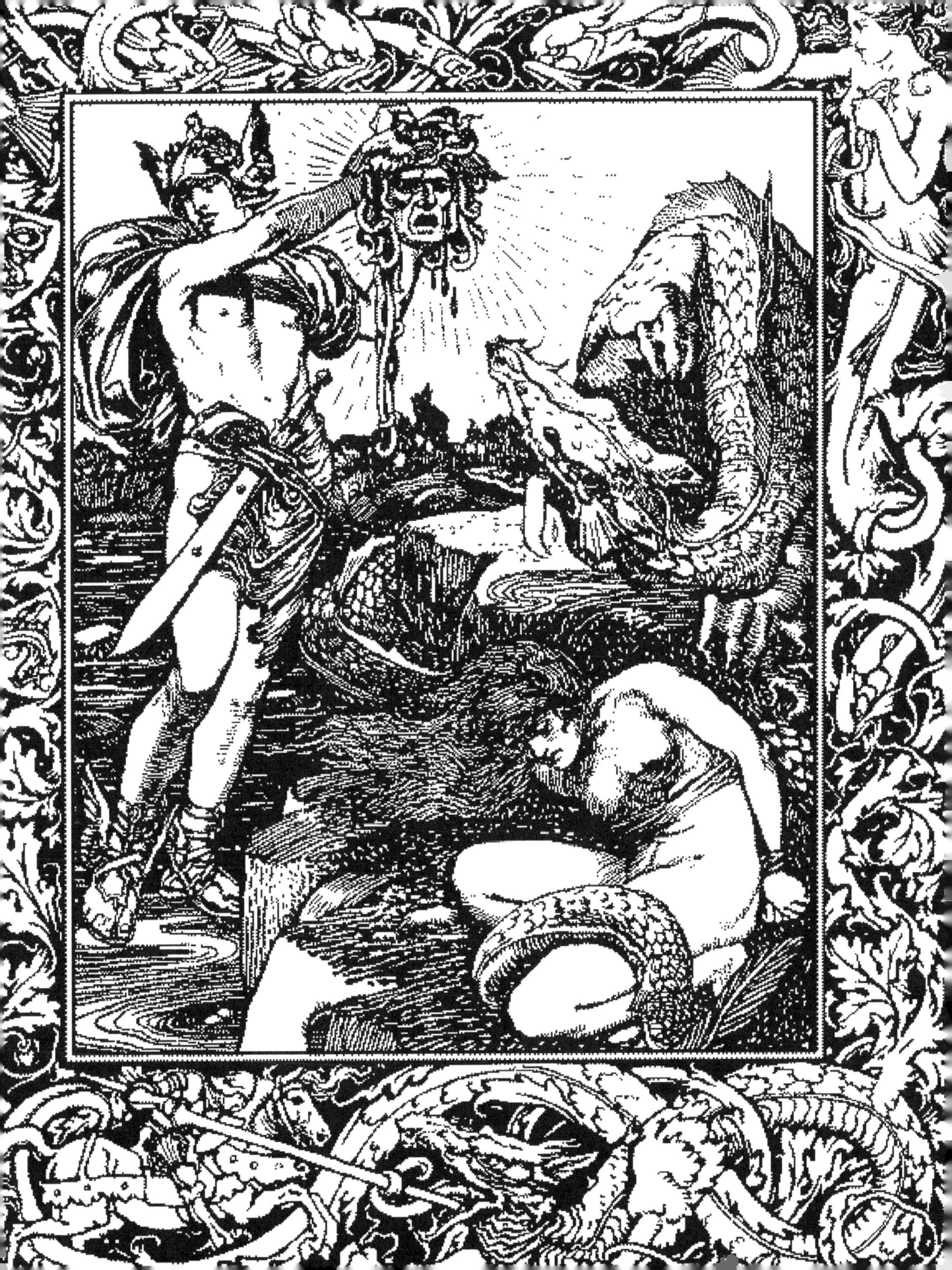

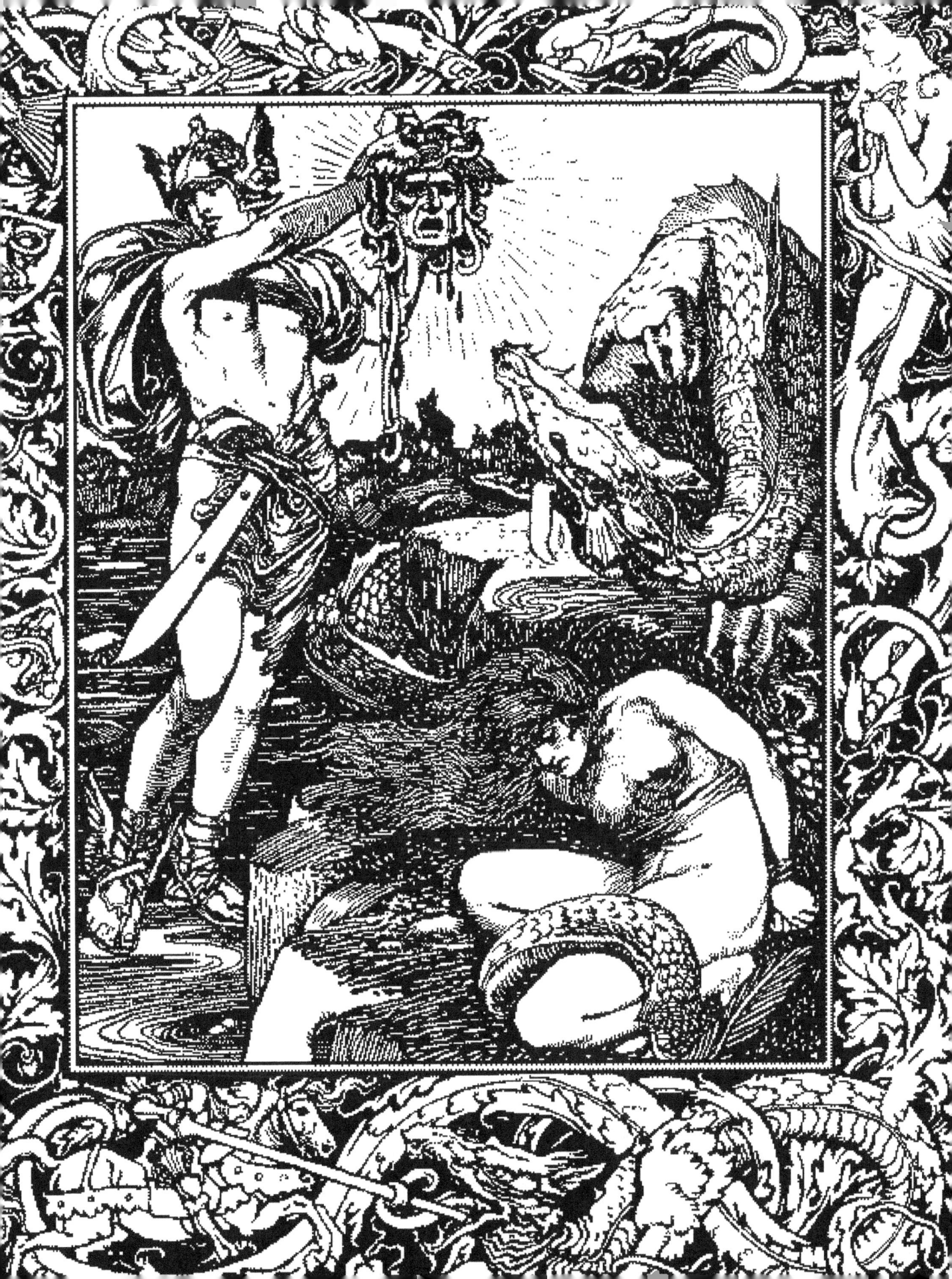

Randy Norman: is a digital artist. You can find more amazing work on Amazon and digitalcoloringbooks.com.

www.ingramcontent.com/pod-product-compliance
Lightning Source LLC
Chambersburg PA
CBHW081308180526
45170CB00007B/2616